The
Birds
Coloring Book

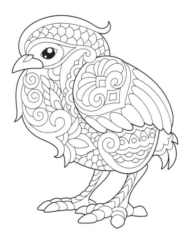

The
Birds
Coloring Book

*Let your creativity
take flight*

SIRIUS

SIRIUS

This edition published in 2023 by Sirius Publishing, a division of
Arcturus Publishing Limited,
26/27 Bickels Yard, 151–153 Bermondsey Street,
London SE1 3HA

ISBN: 978-1-3988-2771-4
CH011156NT
Supplier 29, Date 0523, PI 00003262

Printed in China

Introduction

Whether happily chirping away on their branch early in the morning, moving together in a huge swarm or "murmuration," or swiping your ice cream at the beach, birds are some of the most fascinating and varied of creatures. The variety of their colors, sizes, wingspans, and calls are astonishing, and they are found in every corner of the globe, from the deepest forests and jungles to the highest mountains and most parched of deserts. Some never set foot on land while others are unable to fly at all.

In this collection you'll find birds from the dancing flamingo to the red cardinal to the vividly hued birds of the tropics. Whether you are a keen birder or just a fan of feathers, you'll find a perfect illustration for you to color. So, select a comfortable spot, set your white noise playlist to birds, grab your coloring tools, then take a dive into a coloring book filled with all kinds of feathered friends.

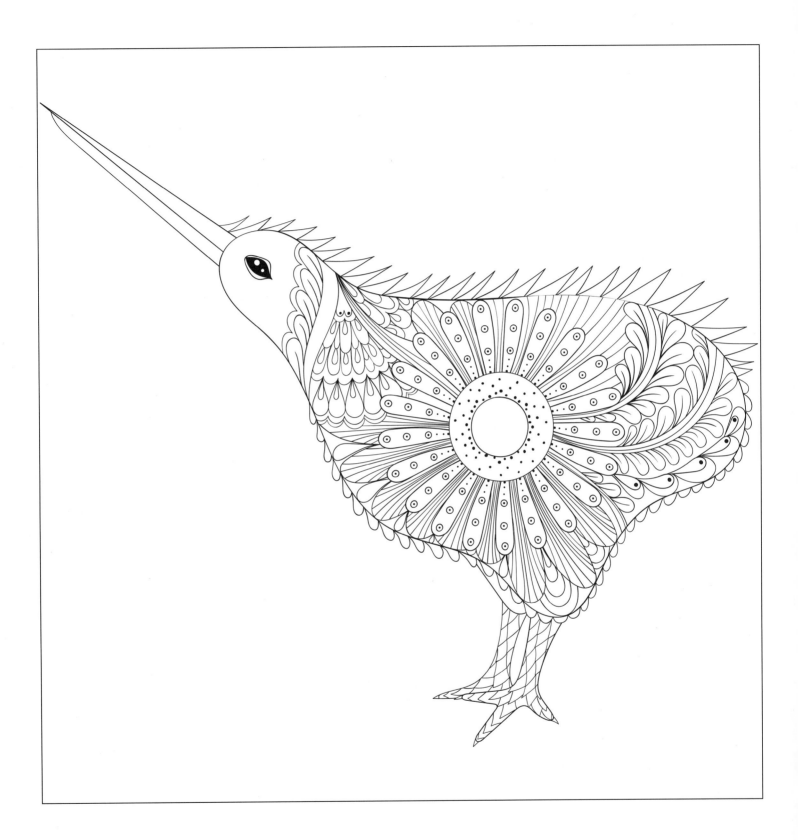

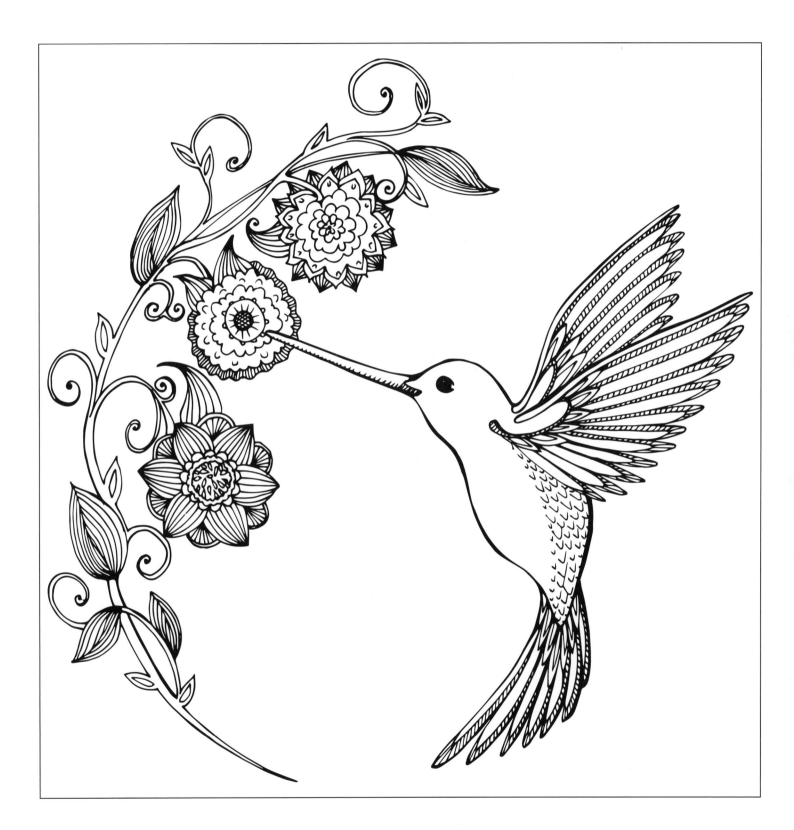

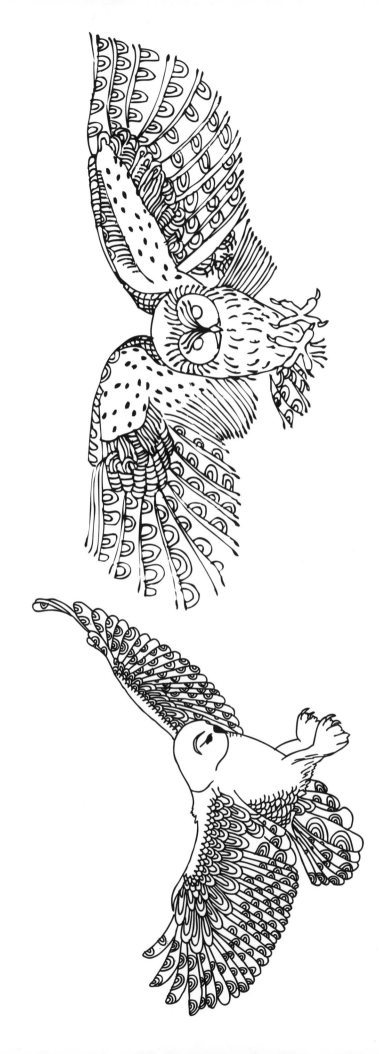
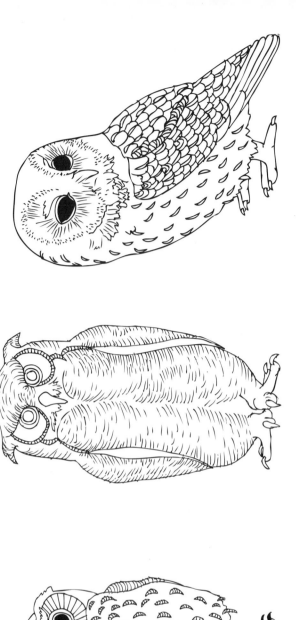
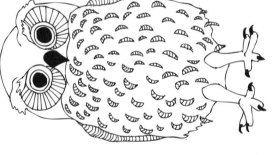
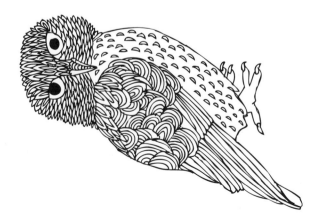

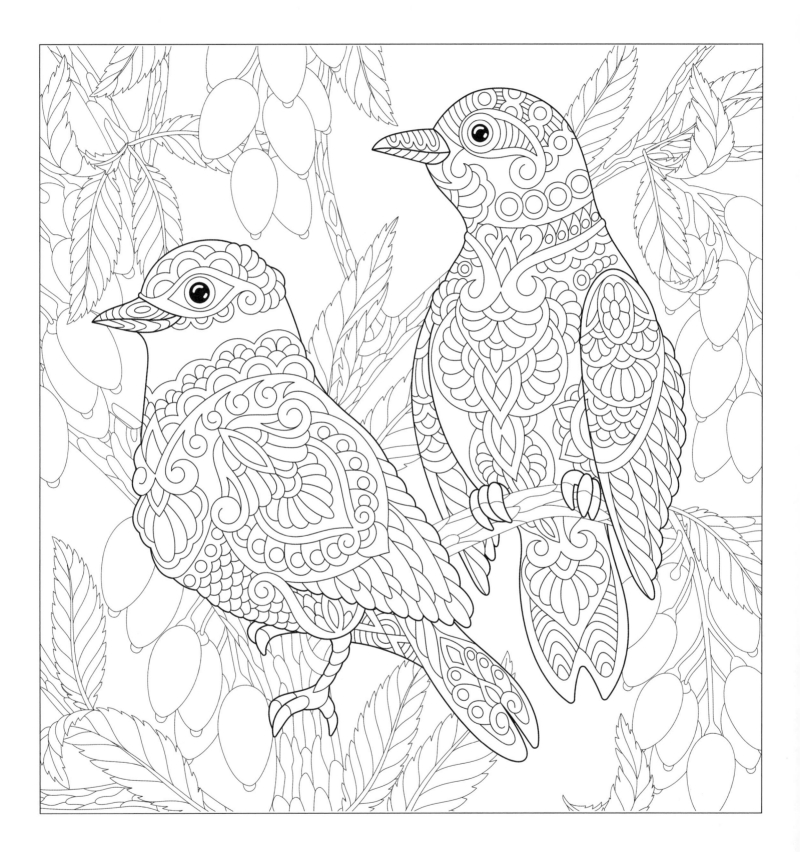

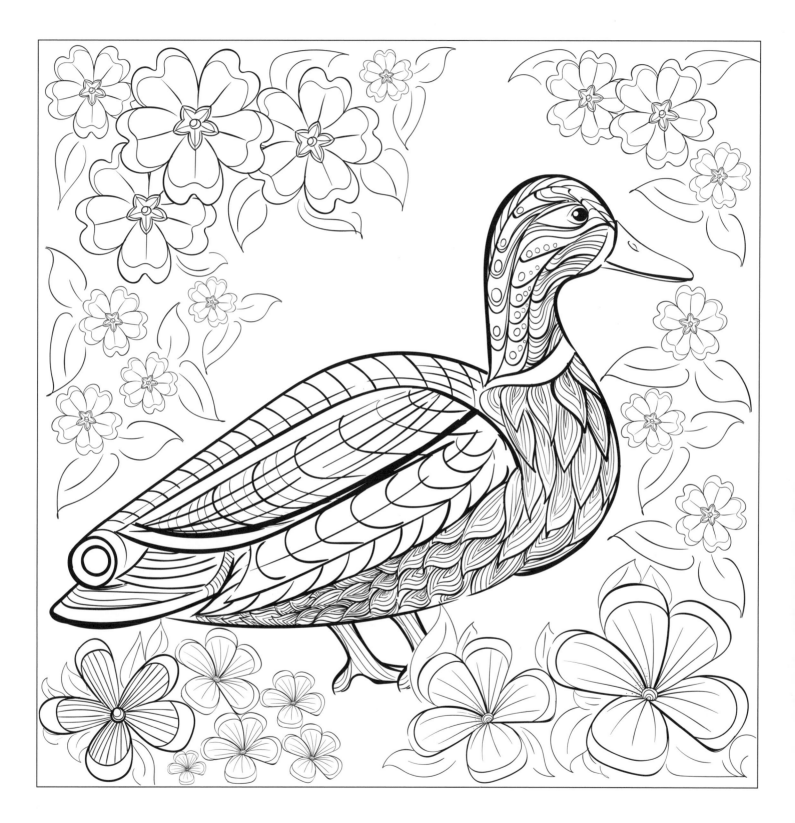

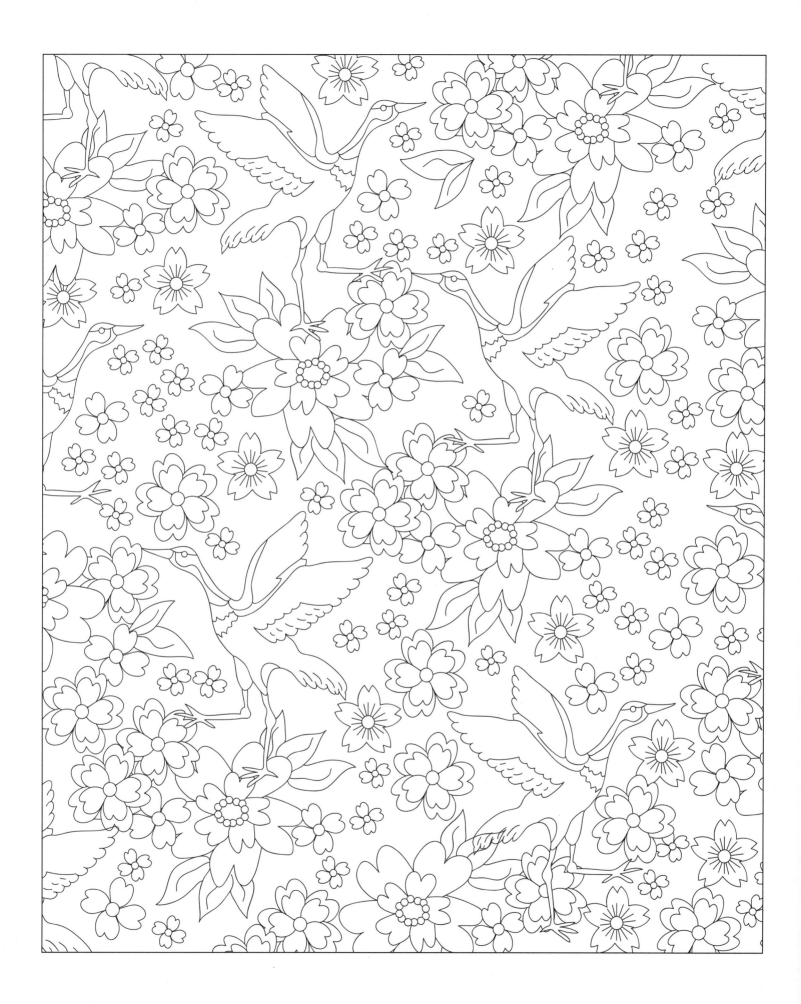

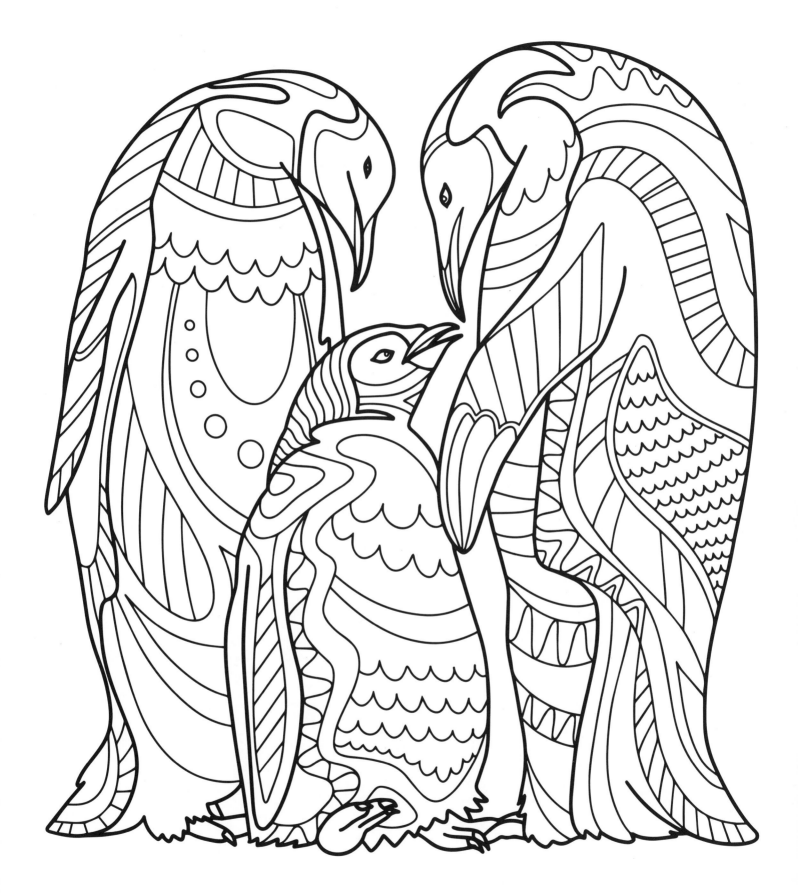

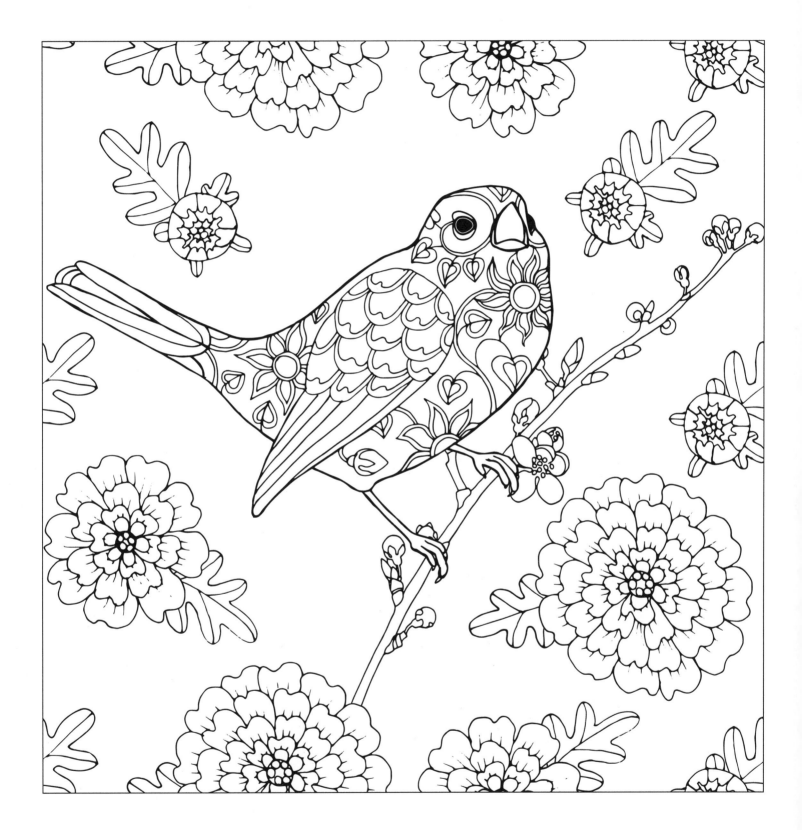

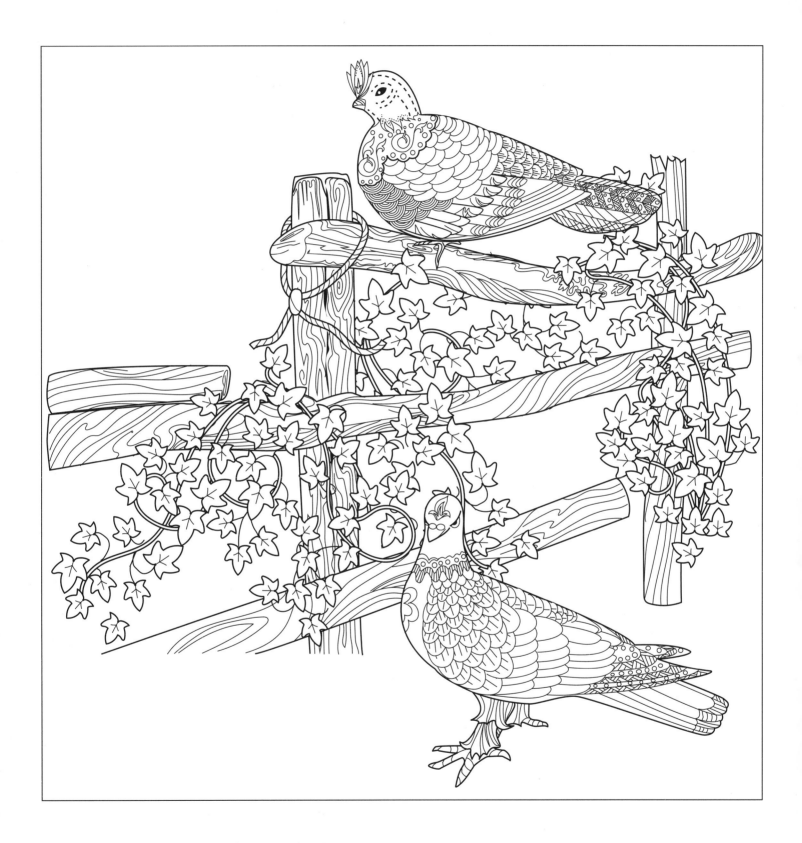

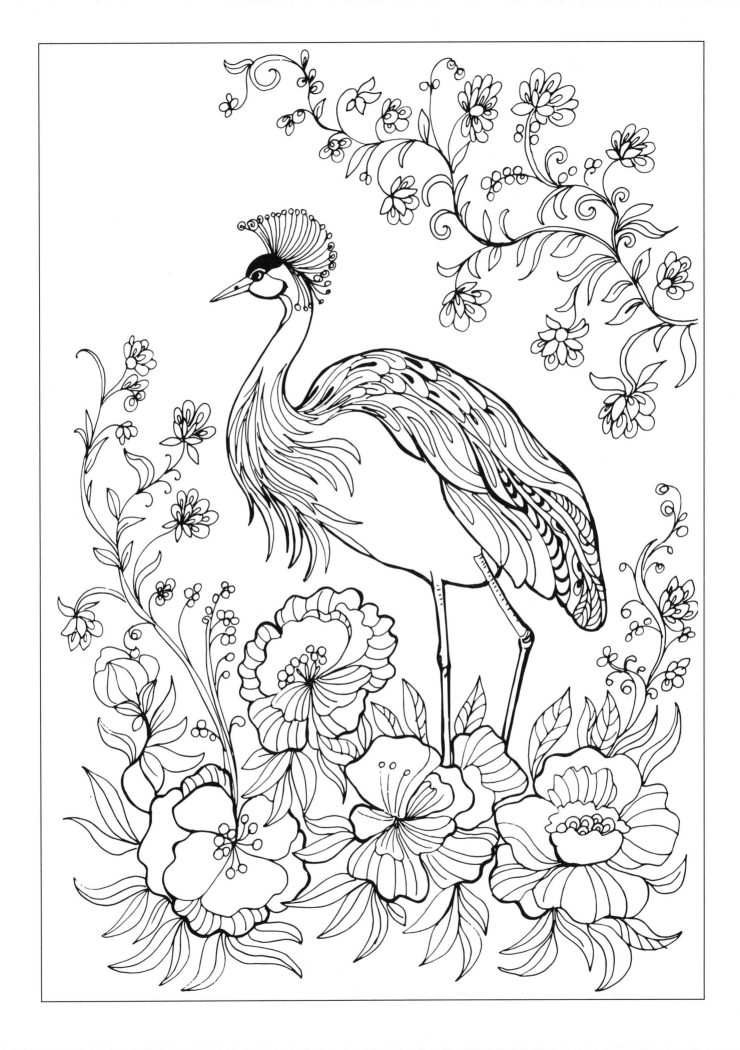

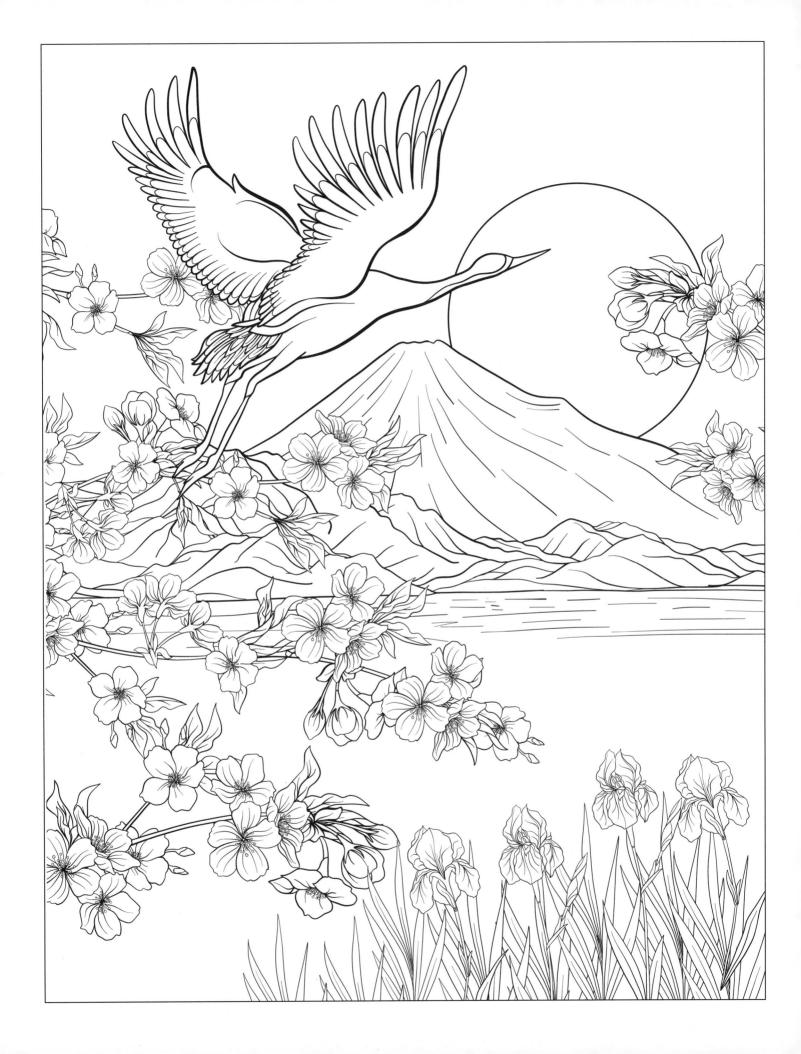

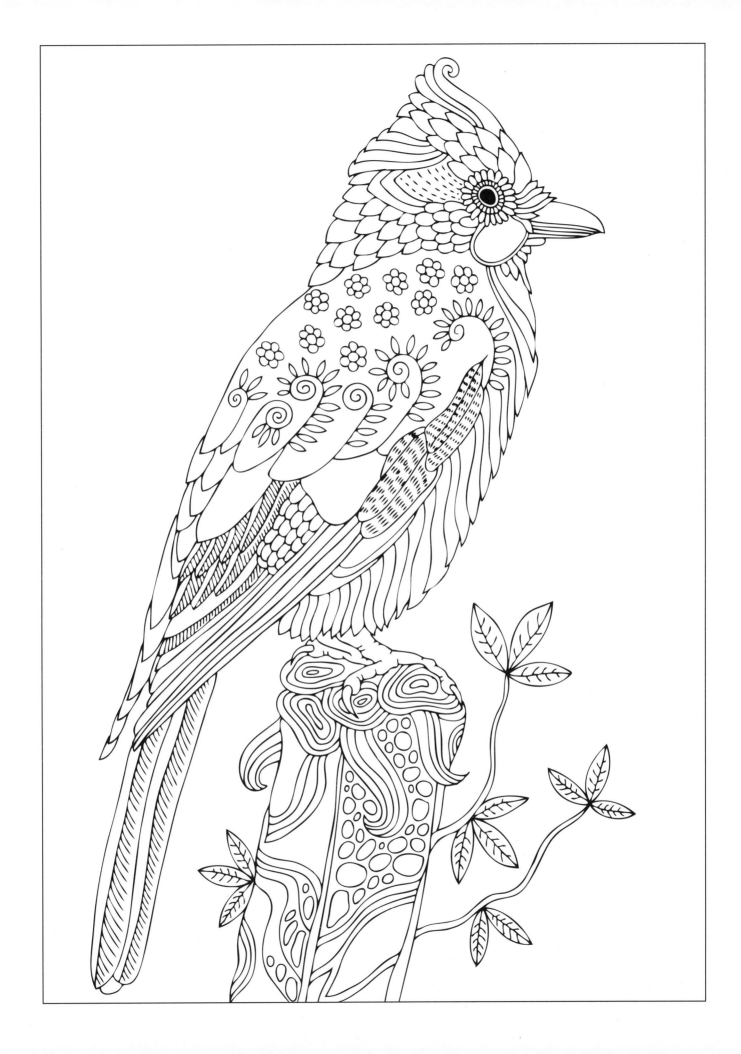

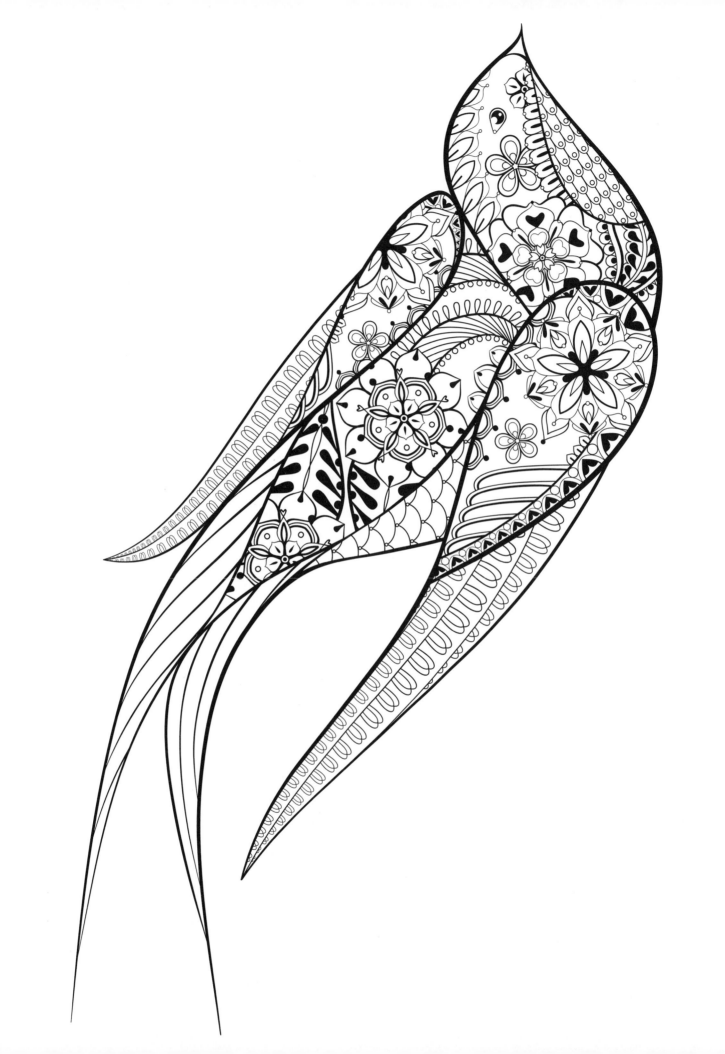

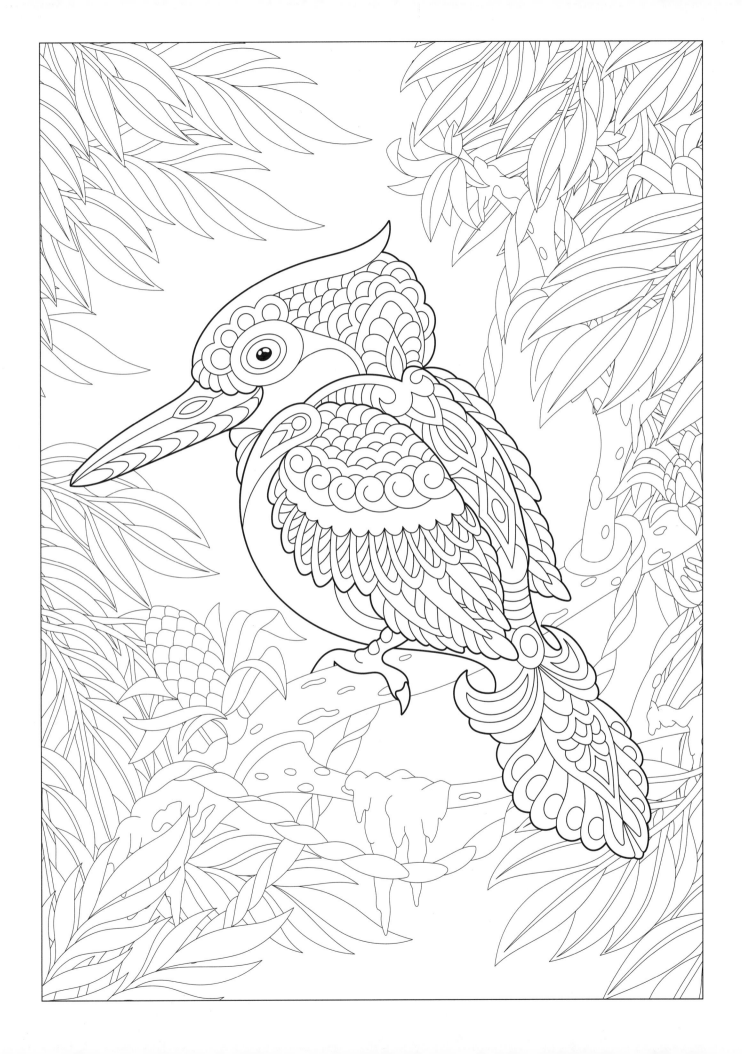

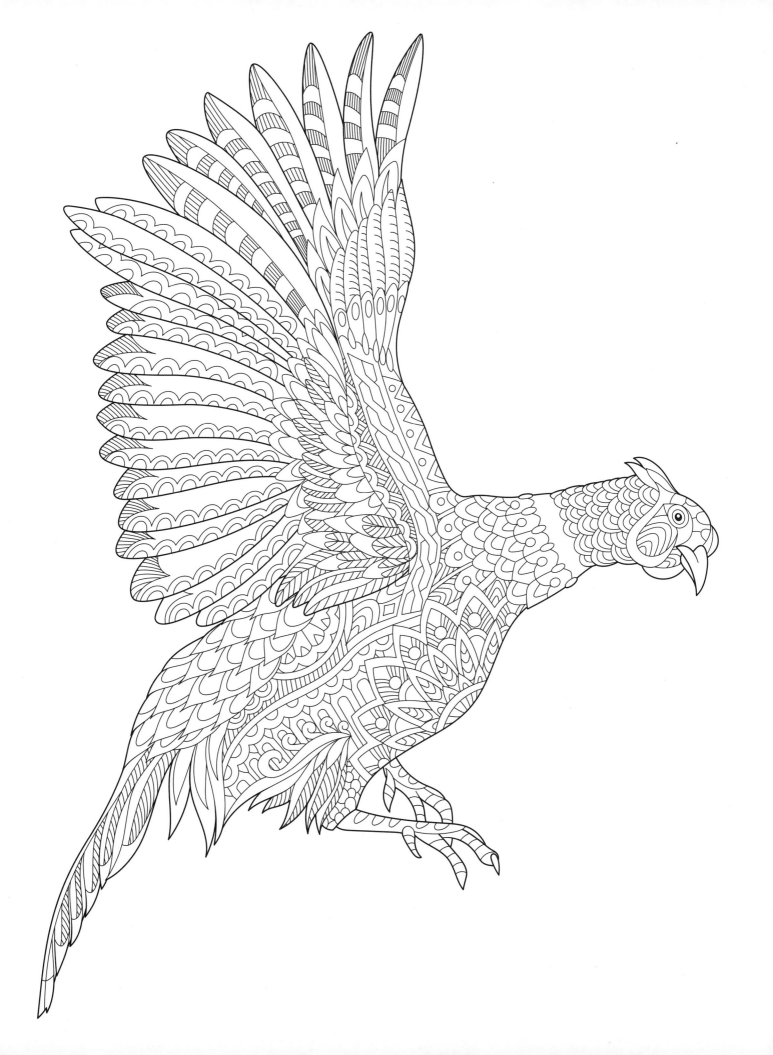

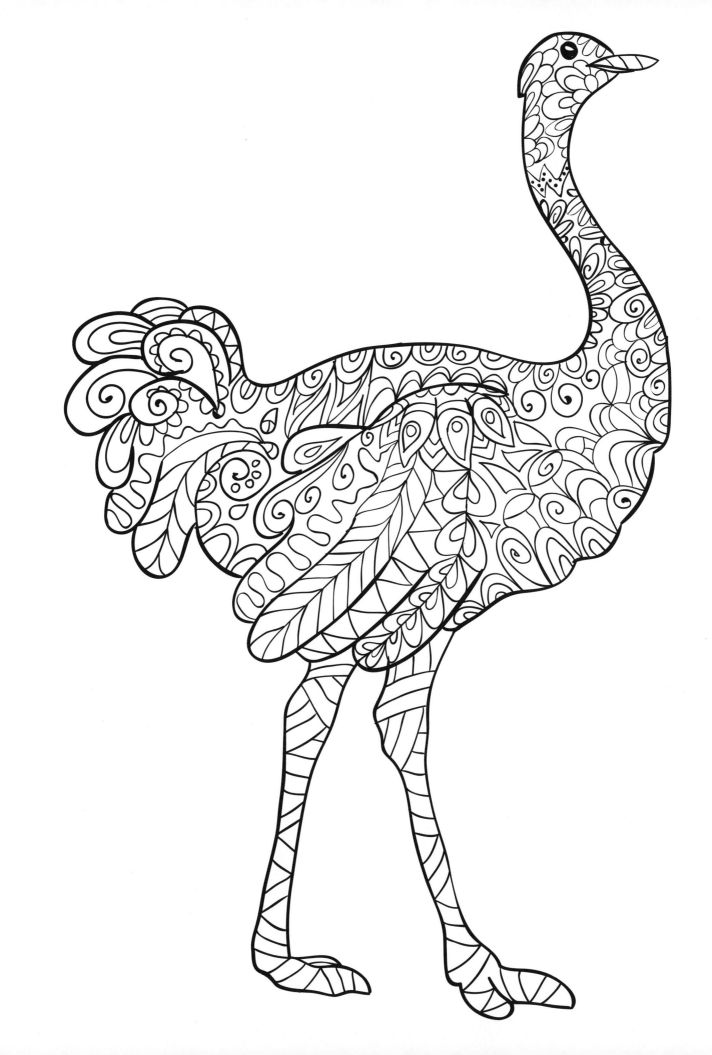

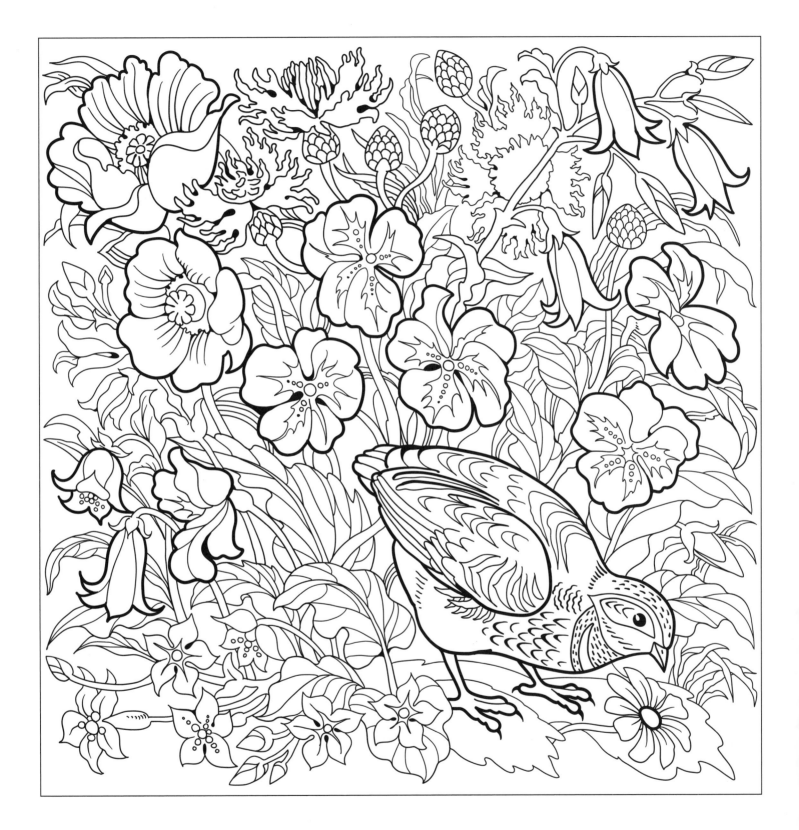

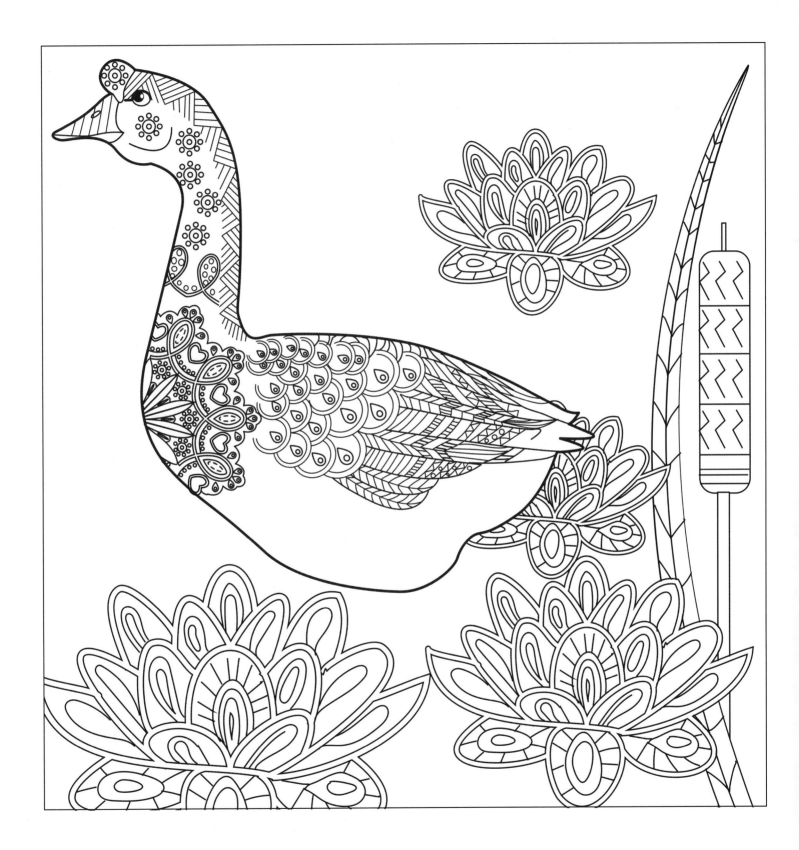

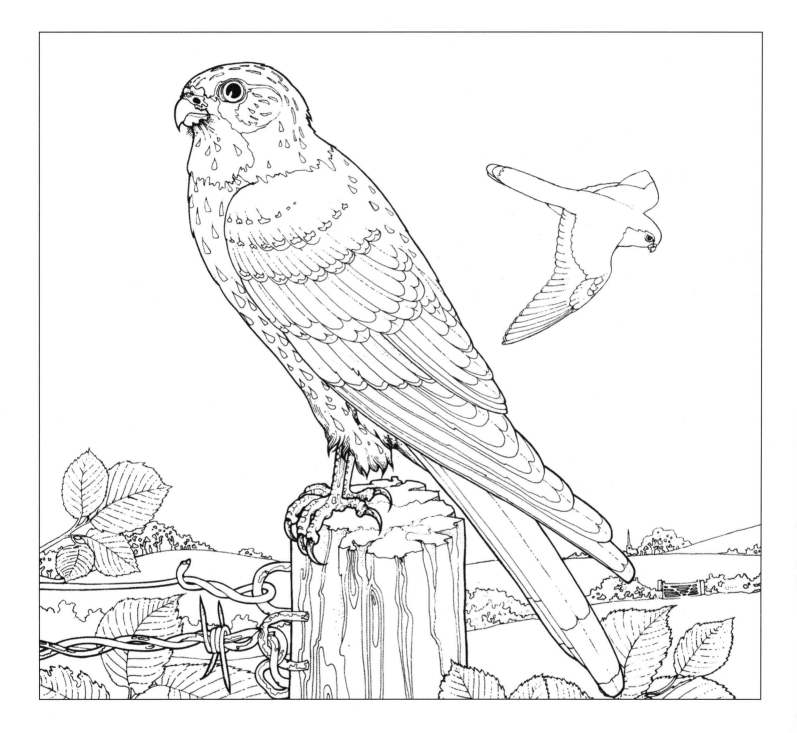

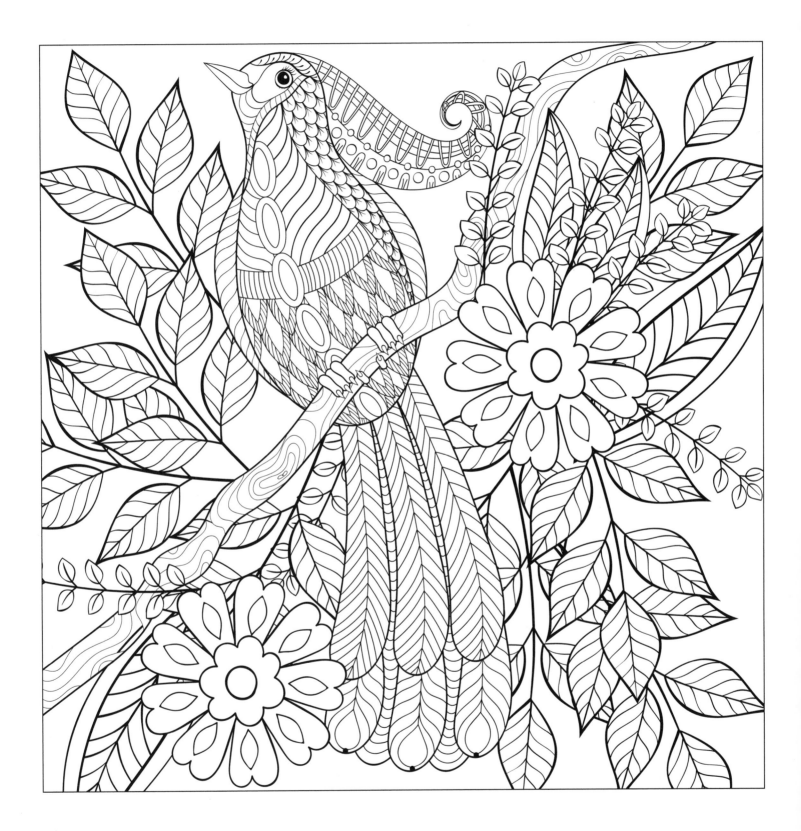

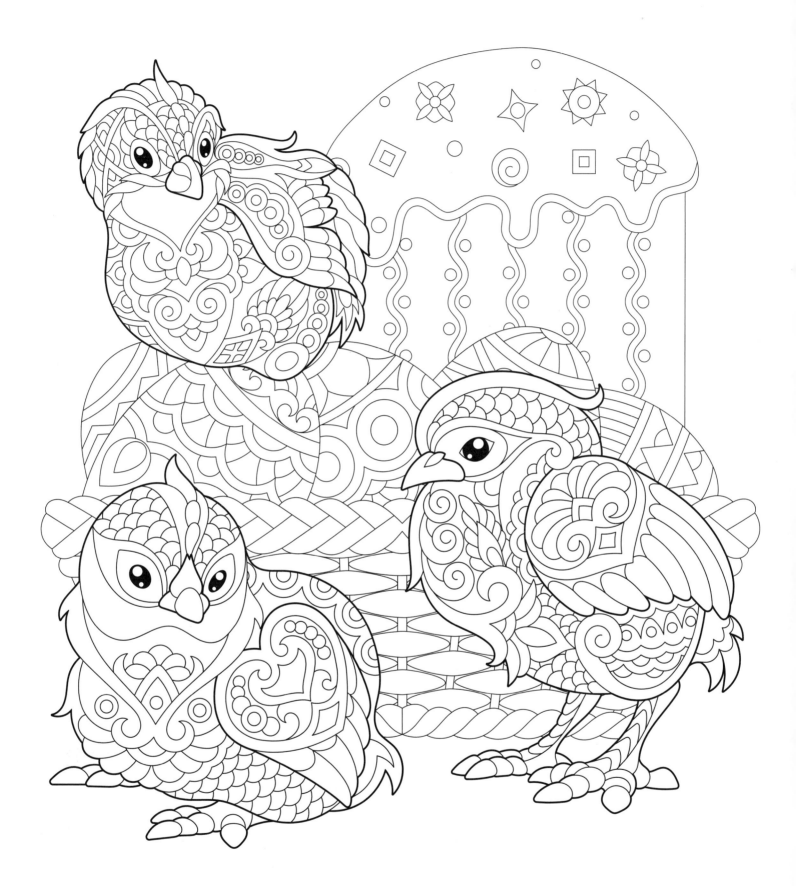

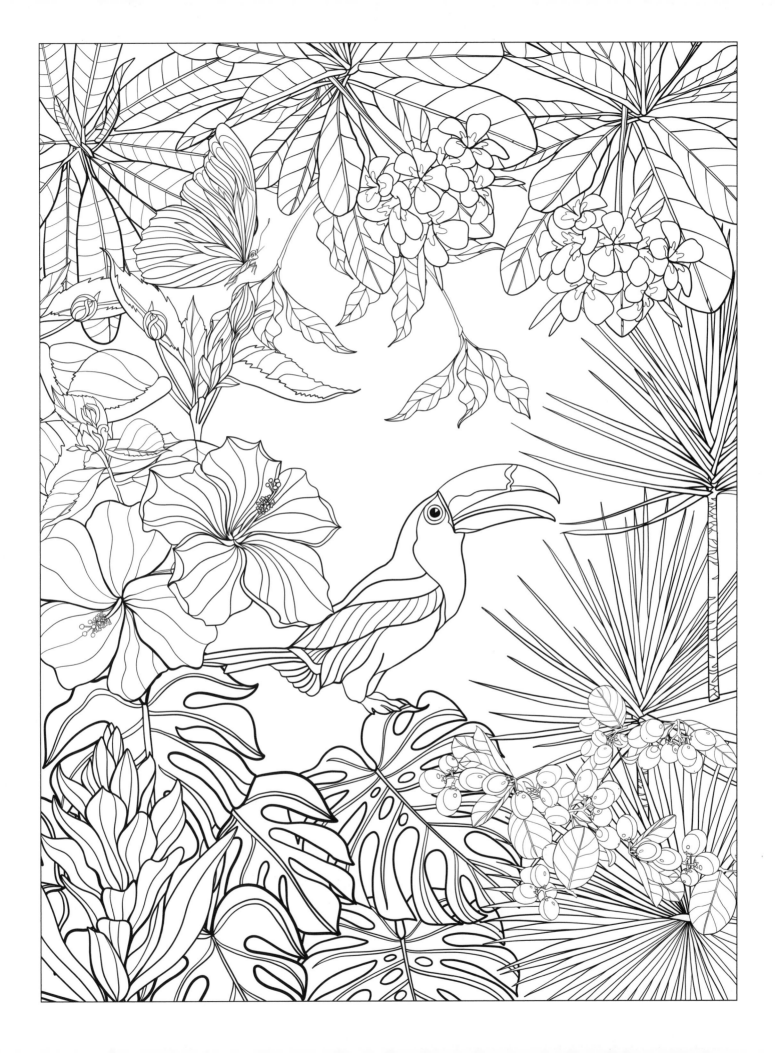

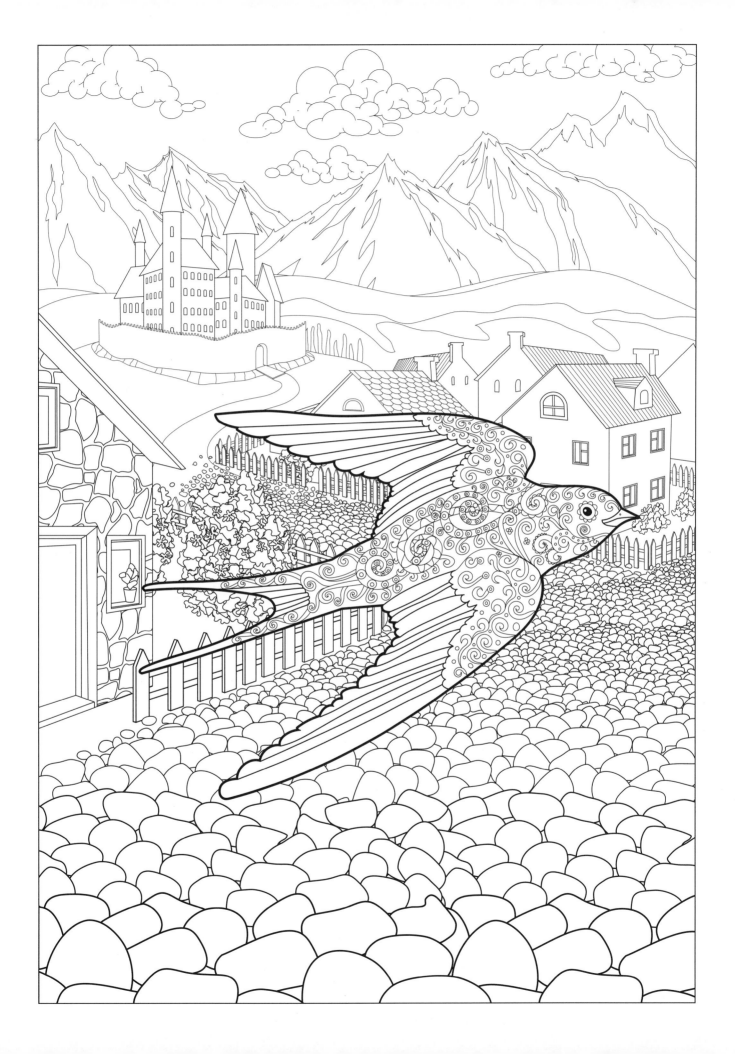

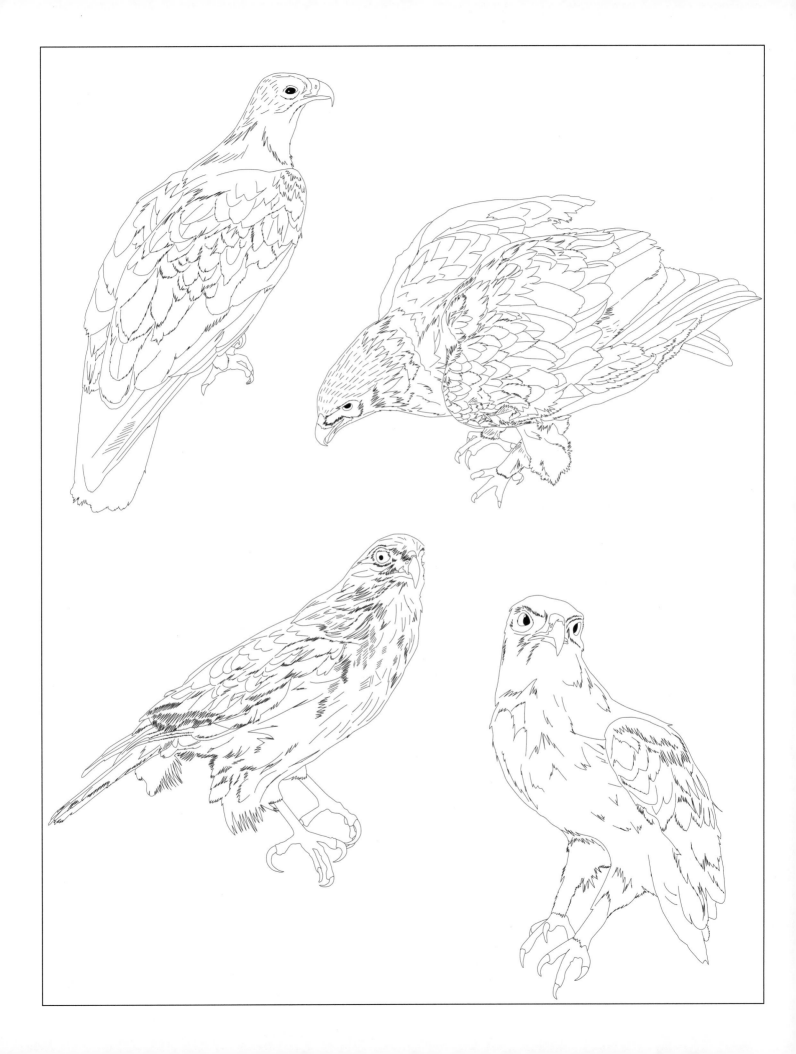

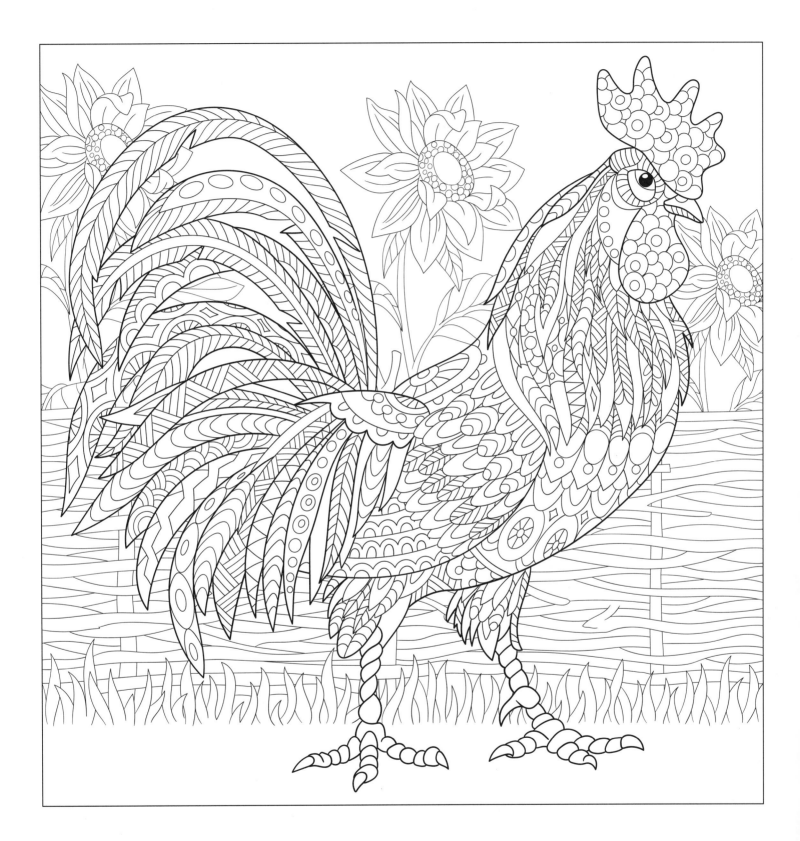

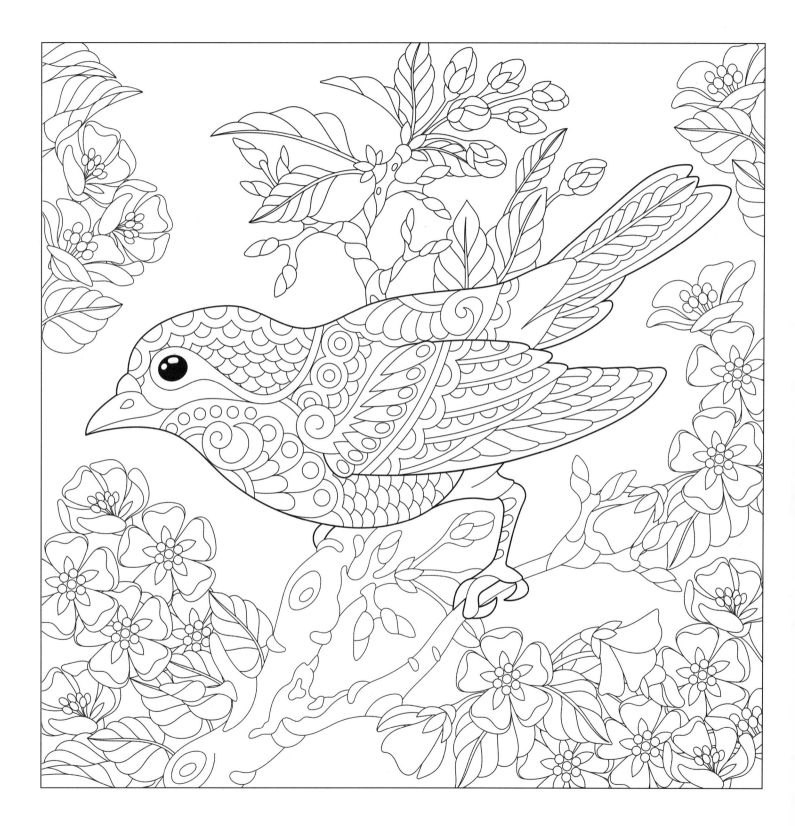

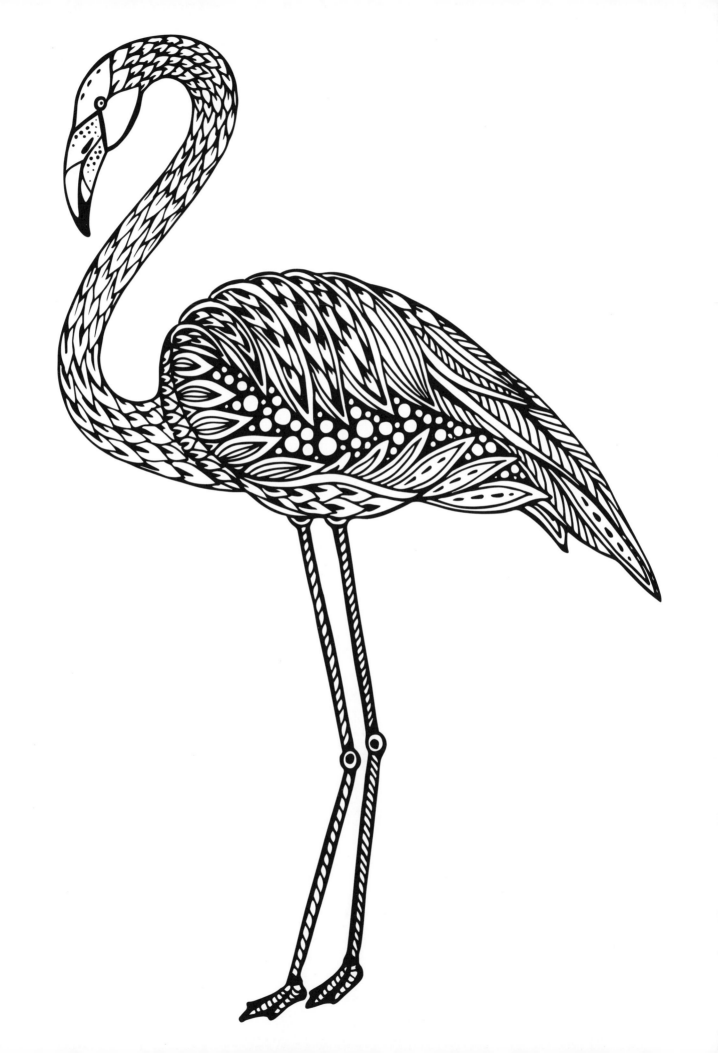

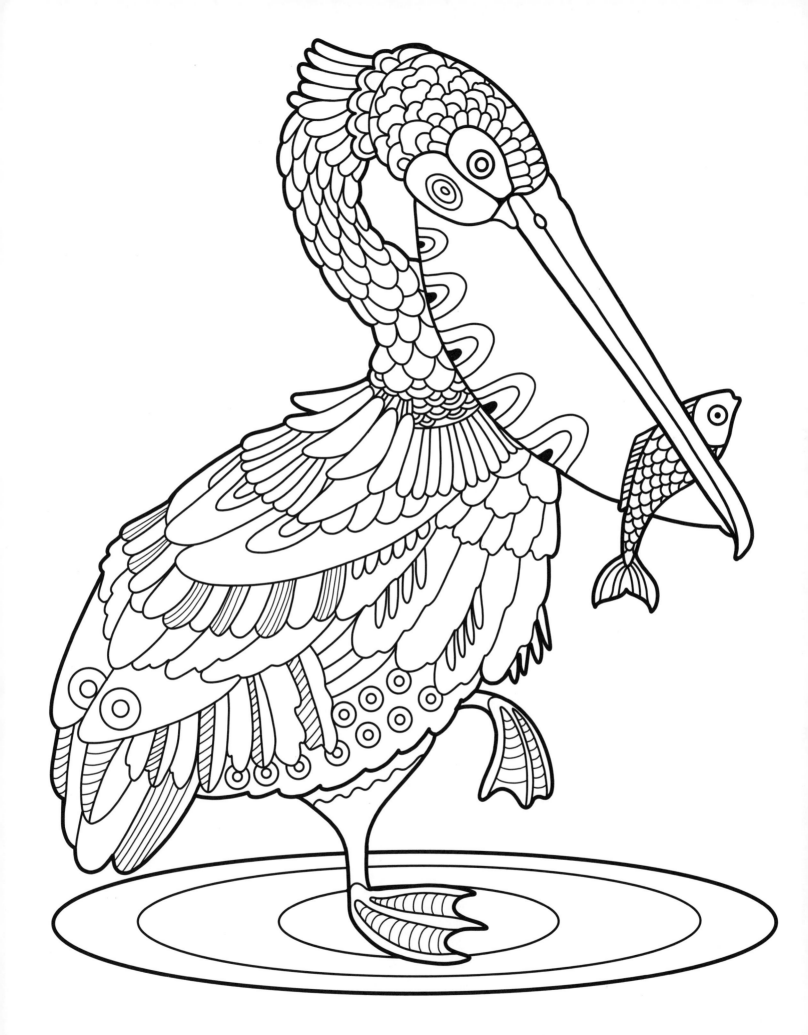

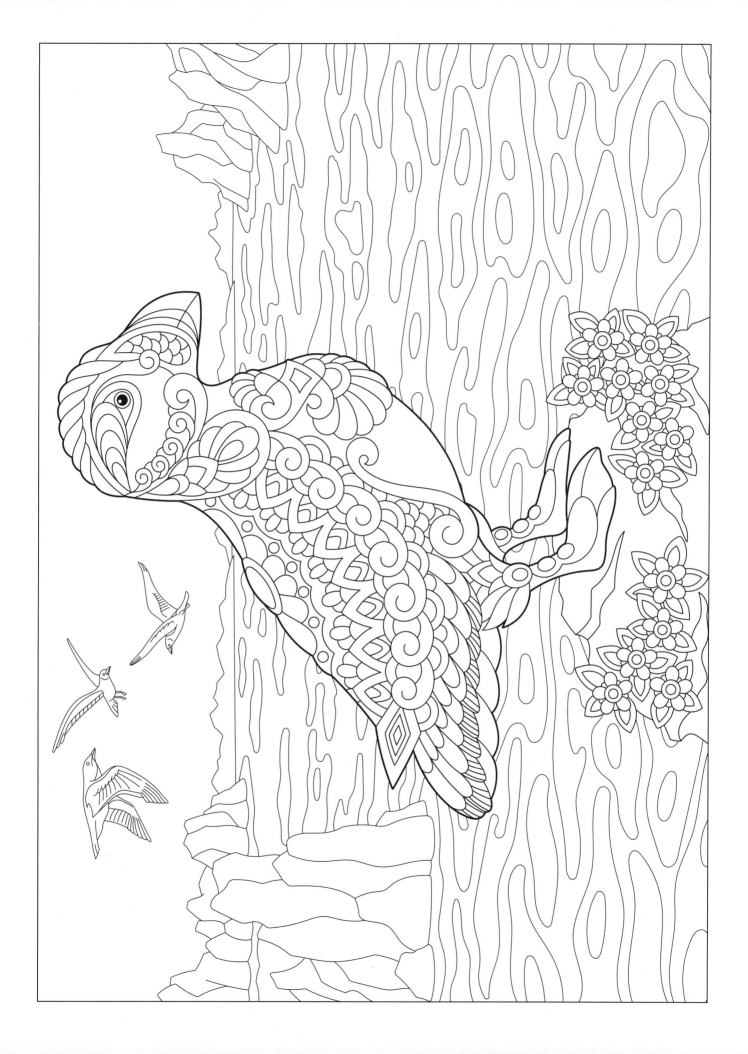

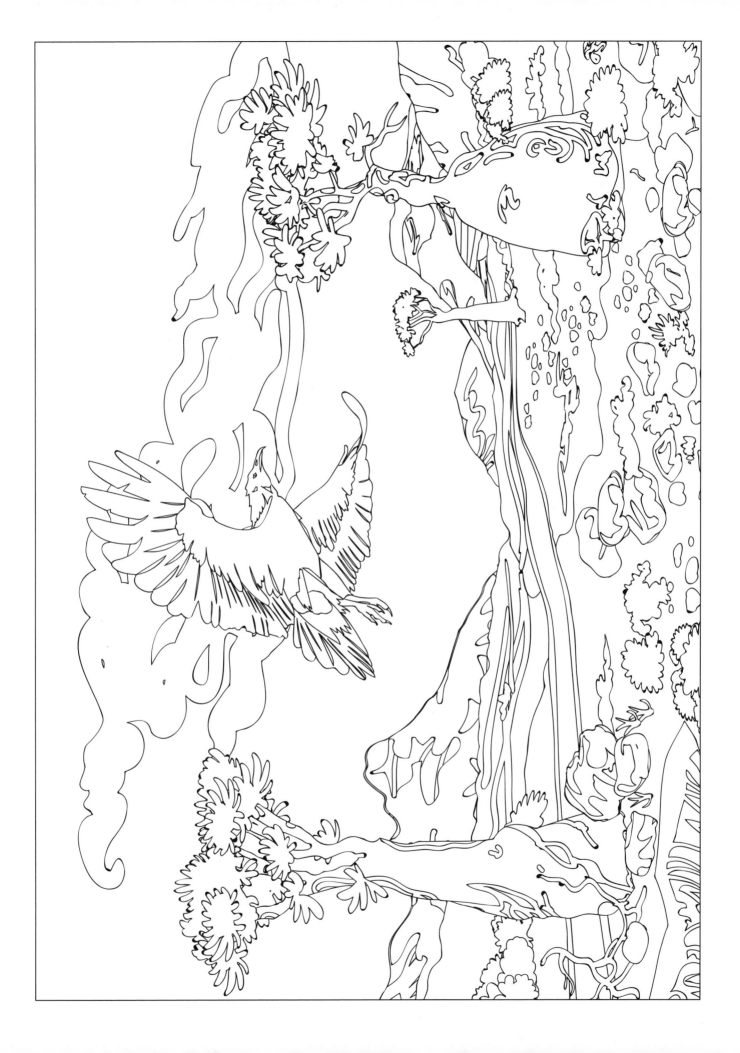

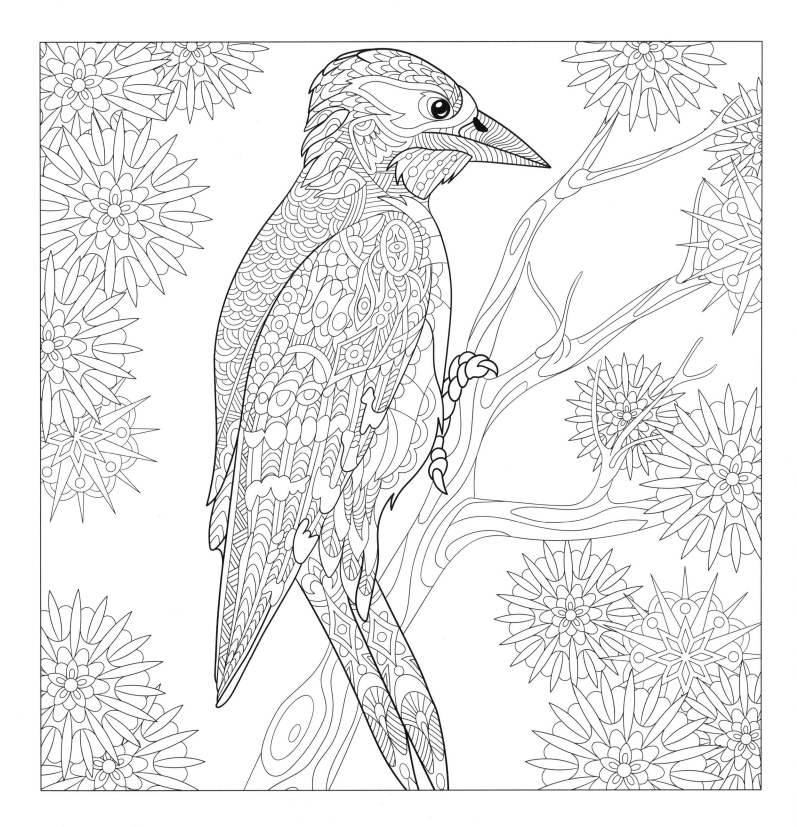

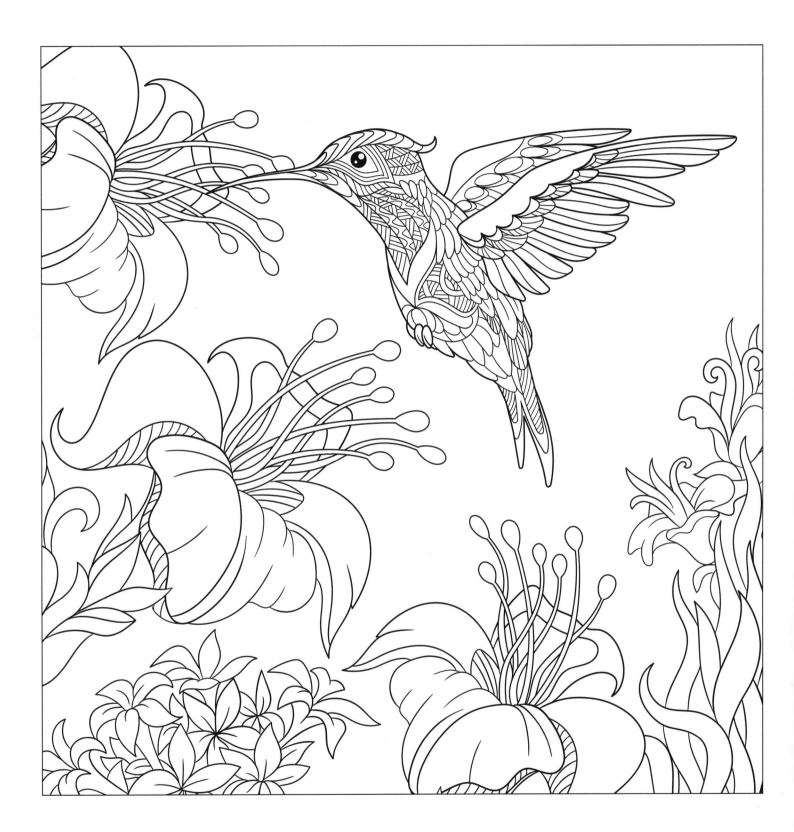

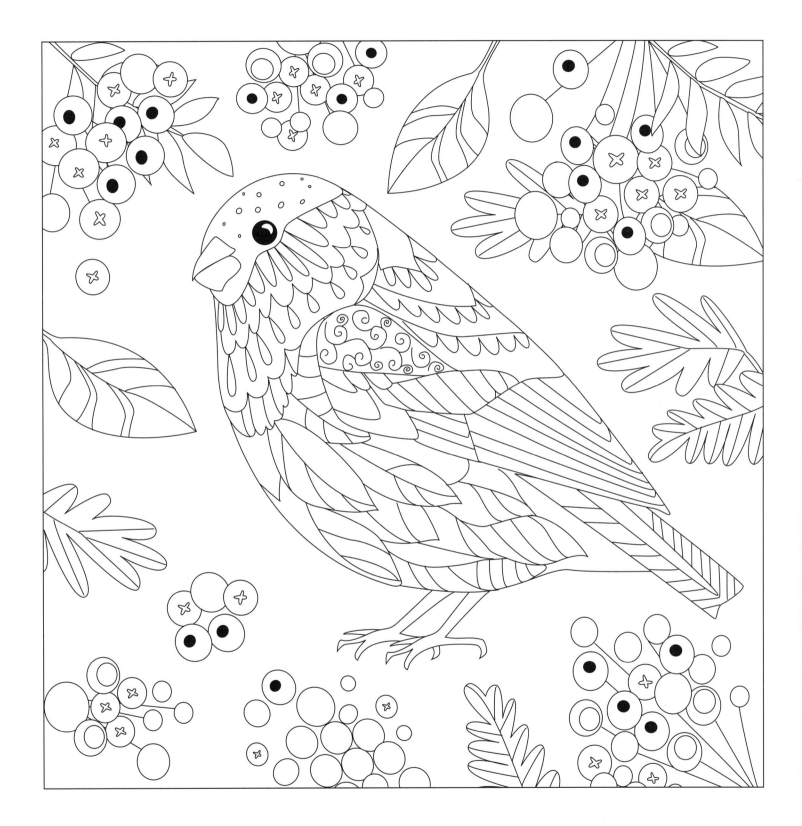

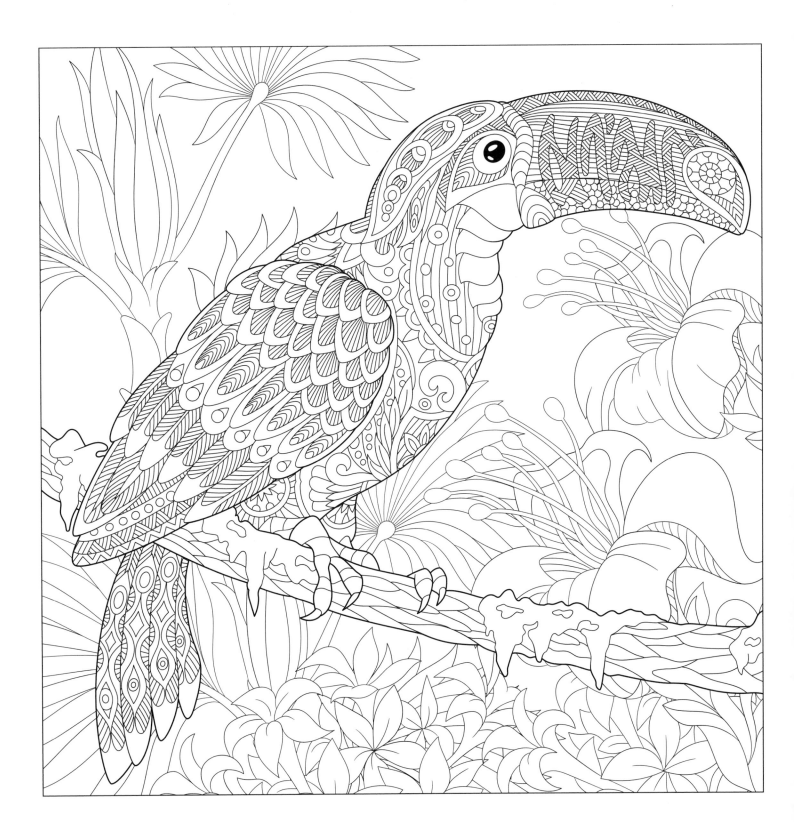

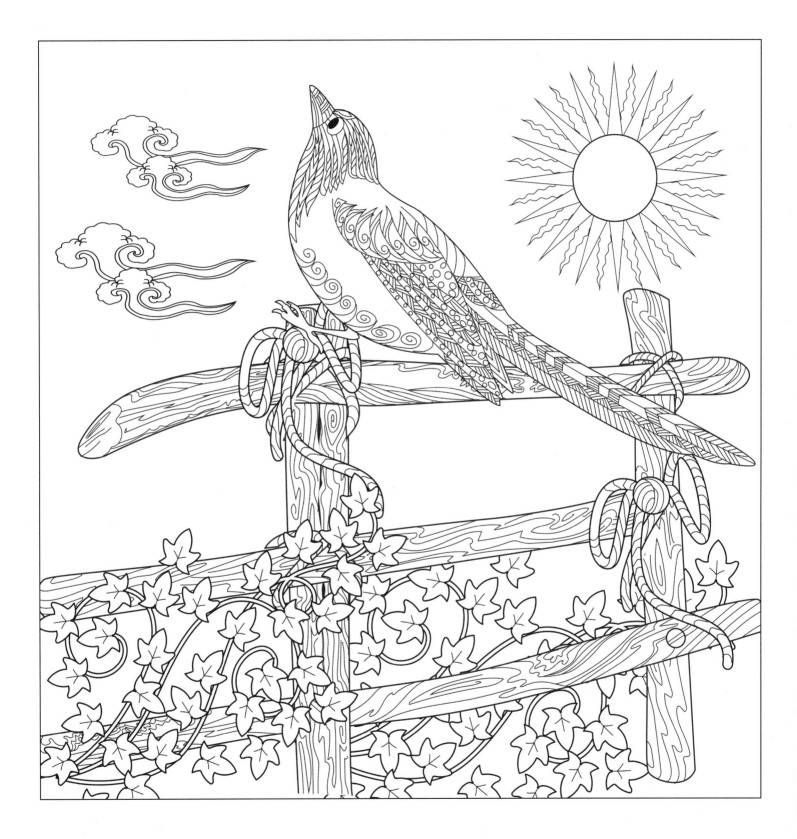

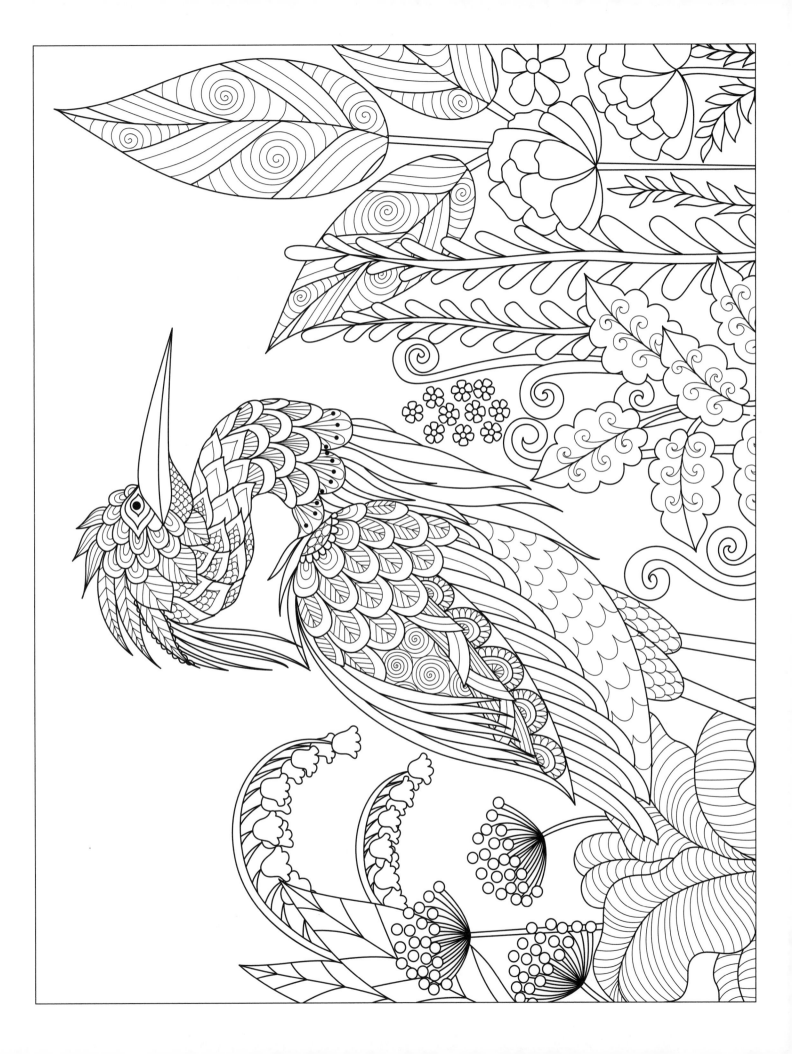

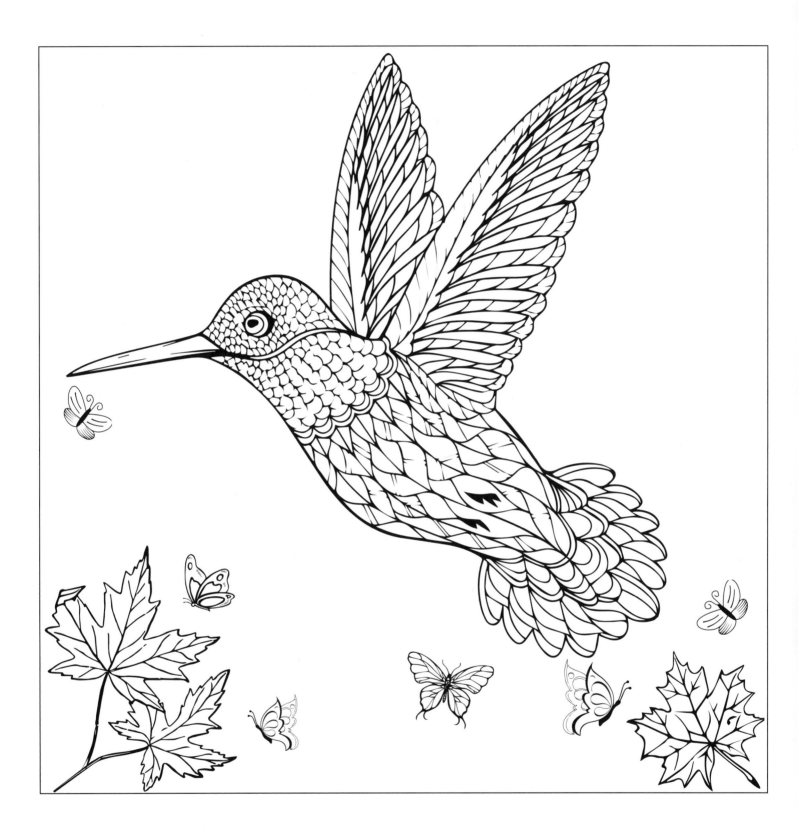

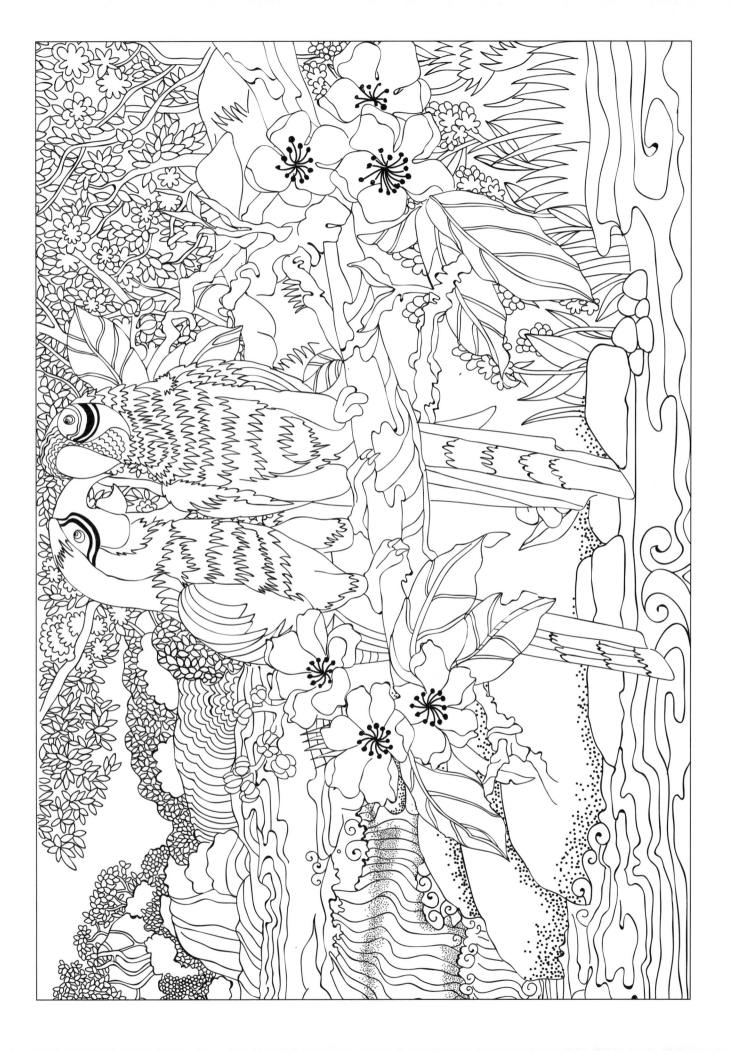

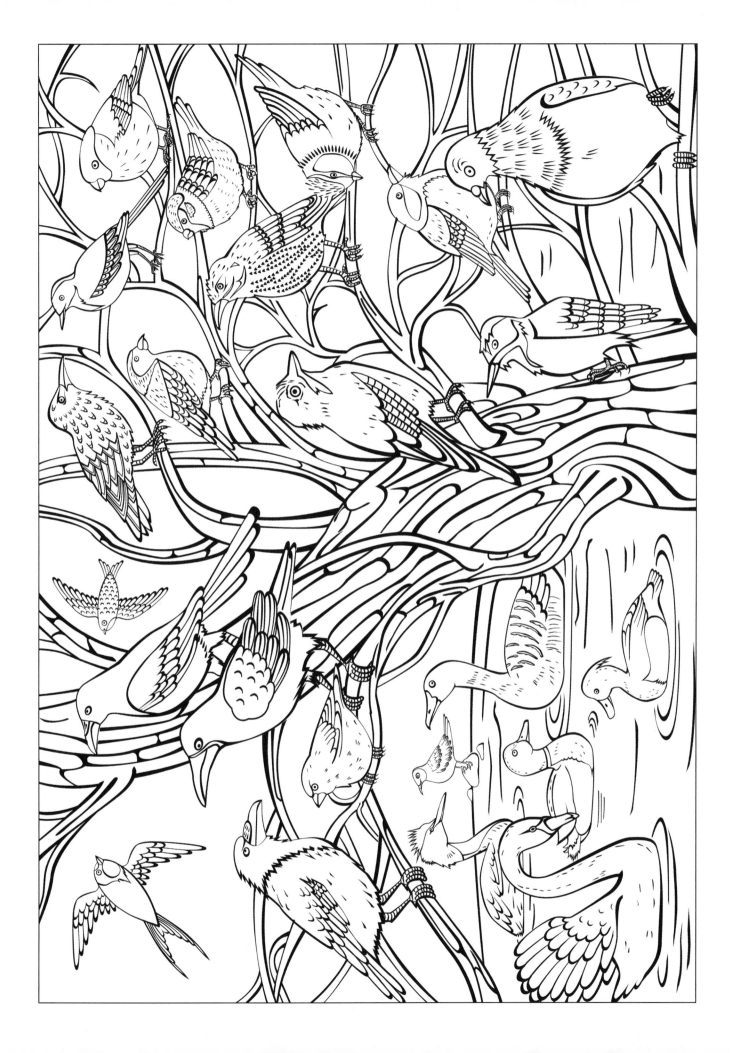

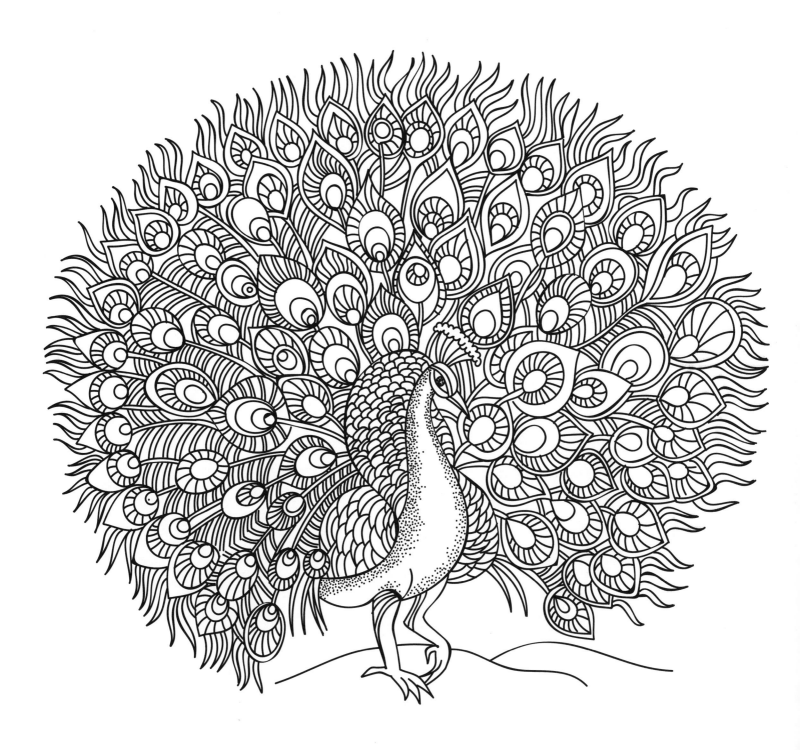

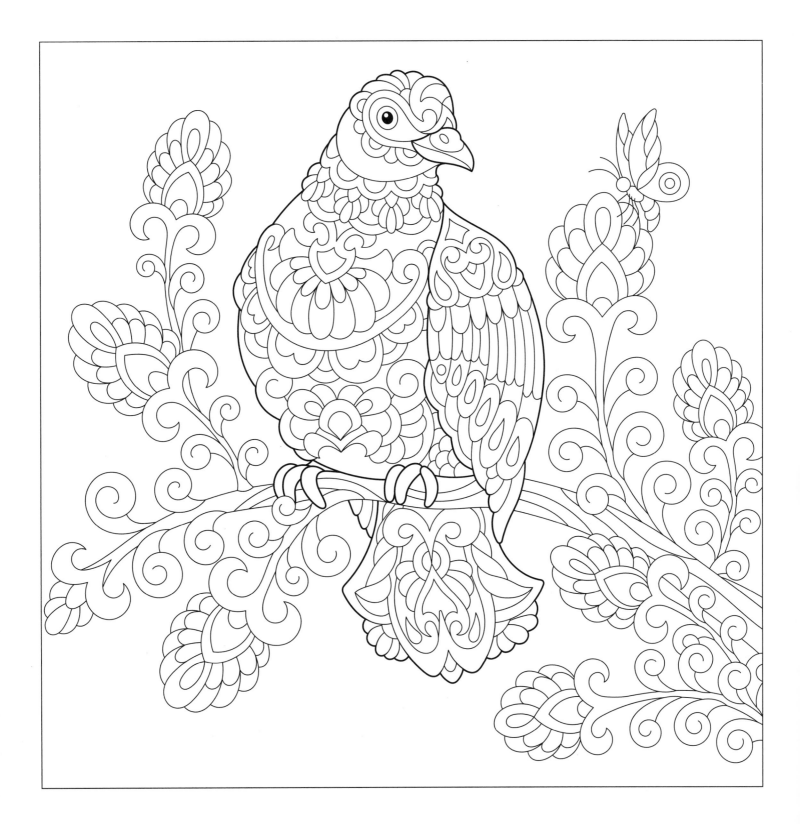

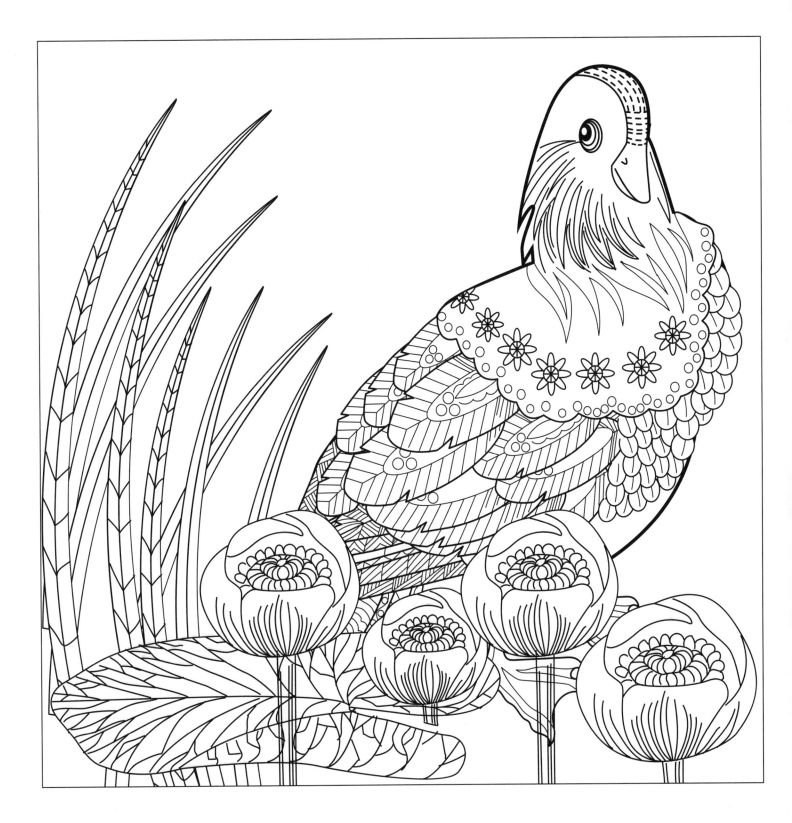

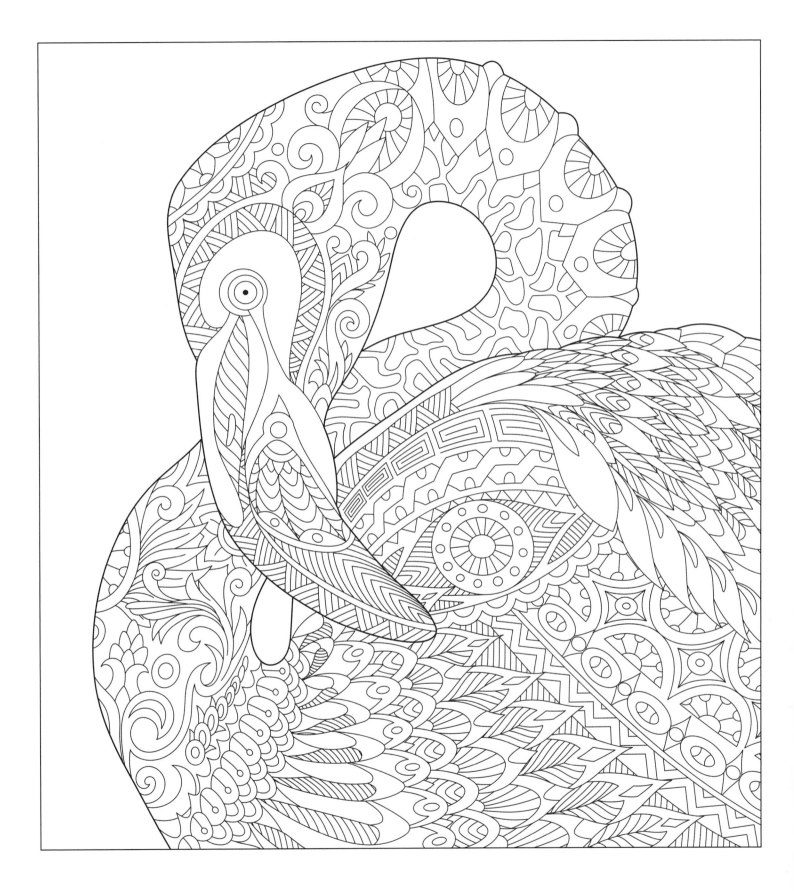

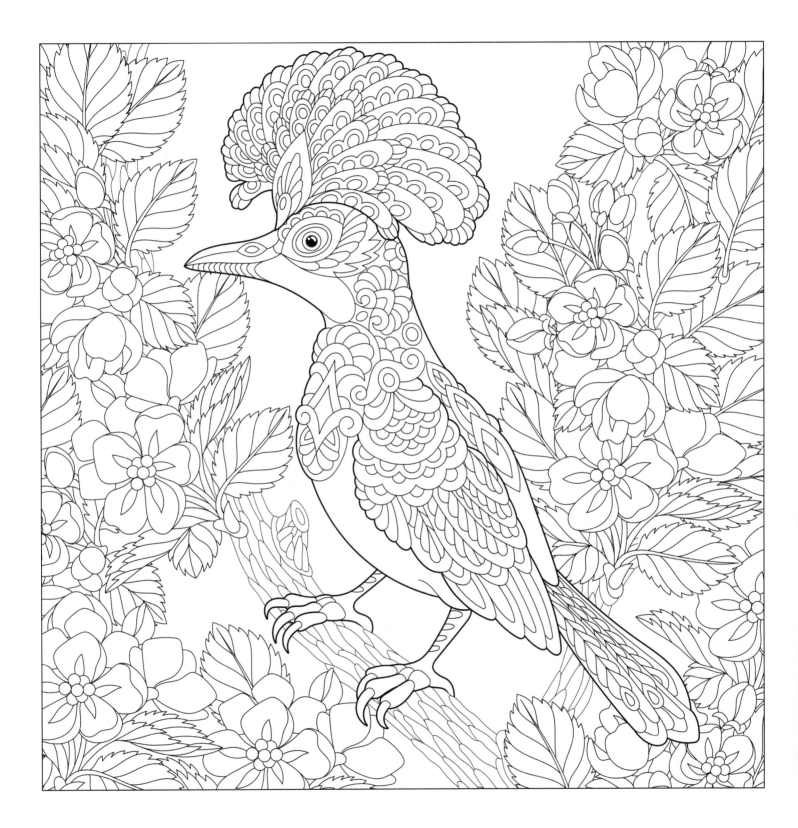

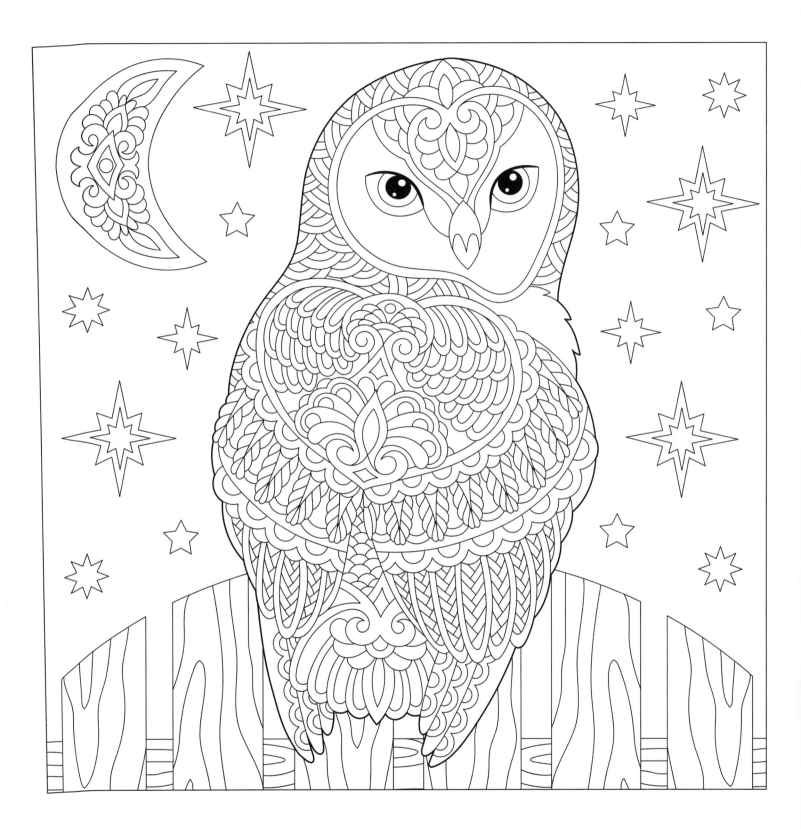